CELTIC DESIGN

Aidan Meehan studied Celtic art in Ireland and Scotland and has spent the last two decades playing a leading role in the renaissance of this authentic tradition. He has given workshops, demonstrations and lectures in Europe and the USA, and more recently the Pacific North West from his home base in Vancouver, B.C., Canada.

CELTIC DESIGN

KNOTWORK

The Secret Method
of the Scribes

AIDAN MEEHAN

With 434
illustrations

THAMES AND
HUDSON

Printed in Great Britain

Introduction

The idea behind this primer of knot-
work is to publish fully, once and for
all, the secret method of the scribes who
created these ornaments, with spec-
ial emphasis on the intelligible form
language of the three grids and of the
craft geometry used in building panels.

I support these ideas with reference to
traditional sources, a variety of plaits
and simple knots, and a study of
spiral knots. As an appendix, I offer
sixty original variations on the ubi-
quitous Triquetra knot, number 7,
page 151. The book is meant to be used
with a pencil and paper at hand. I
hope readers will reproduce the de-
signs themselves, and apply them.

Chapter I
the
three
grids

IN knot design, the first and most important thing to know is how to lay the grid of dots which determines the form of the resulting knot. To do this, it is necessary to analyse the dot grid of a knot into three classes of grid: first, THE PRIMARY GRID; second, THE SECONDARY GRID; third, THE TERTIARY GRID. Let us look now at a simple knot to see how it depends upon all three grids in its construction. The knot is the FOUNDATION KNOT. It looks like this:

The foundation knot.

fig.1

Two-by-two Primary, Secondary, Tertiary
Dot Grids.

Primary is the square grid.
Each side of the square is
two squares. So the grid is
called a "2x2 Primary".

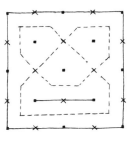

fig. 2

Here we have the centres of
the squares. This grid is
a "2x2 Secondary" grid.
A "break line" is placed be-
tween two secondary grid points.

The 2x2 tertiary grid is
the path taken by the knot.
Each point on the tertiary
grid is the intersection
where the path crosses over
or under itself, except where cut by a breakline.

The combination grid.

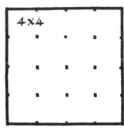

When you combine a 2x2 primary, secondary, & tertiary, the result is a 4x4 primary. Compare this with the grid on the previous page, fig.2. Can you pick out the primary grid, 2x2, embedded in the 4x4? The secondary? The tertiary?

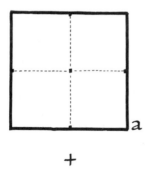

a, 2x2 primary plus
b, 2x2 secondary ...

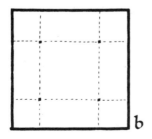

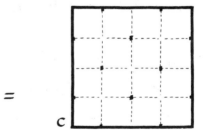

equals c, 2x2 tertiary.
a+b+c=d, 4x4 primary.

fig.3

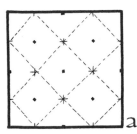

The breakline.

With no breakline, the
tertiary grid is a circuit
of a knot, or plaitwork.

The 2x2 square produces TWO links on
the tertiary grid. Can you see them in fig.4,
a?

In fig.4b you see the
line of the knot: it follows
the diamond pattern, terti-
ary grid.

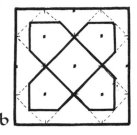

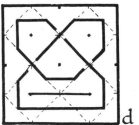

= +

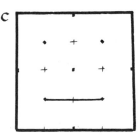

b, 2x2 plait plus
c, breakline equals d.

fig.4

[11]

 S we have seen, the Foundation Knot, *fig. 1*, is derived from a grid, which may be seen as a combination of three distinct grids, which I call the primary, the secondary and the tertiary grid.

O n page 9 we see the three grids in operation, building the knot through three stages. The primary grid divides the area into square spaces, so that we can call the knot a 2x2 knot. There are two spaces across and two down. In order to reproduce a knot design in the traditional way, it is first necessary to be able to count the spaces and then draw the primary dot grid. The primary grid here defines the outer edges.

C ounting from the corner of the box there are two primary cells a~ long each edge, fig. 2. Each is a square, and the four cells meet in the centre. Each square has its own centre point, where lines joining opposite corners cross diagonally. The centre of the square is as obvious, as necessary as the centre of a circle. Every cell in the primary grid must have a centre point. Hence the secondary grid - the four centres form a single square cell over lapping, binding together the primary grid ~ rises spontaneously within the primary grid.

T he primary grid and the second-ary grid intersect, unite to produce a third grid; again, spontaneously.

Chapter II
King
Solomon's
Knot

C ompare *fig.3c* and *fig.4a*. You can see that by joining the tertiary grid points you get the form line of a 2x2 knot, which is the simplest on two accounts:

1, we cannot draw a square knot, or plait, on a grid less than 2x2;
2, there is no breakline in the 2x2 plait.

K nots are made with breaklines on the primary grid, or, as is the case with the Foundation Knot,

on the secondary grid, fig. 4d. On
the other hand, plaitwork corresponds
to the diamond pattern of the terti-
ary grid, uninterrupted by any
breakline; fig. 4a, which illus-
trates the 2x2 plait perfectly,
raises one small problem. Accord-
ing to the definition we have just
made, it is clearly a plait; yet, at
least since Renaissance times, it
has been called 'King Solomon's Knot'.
In view of this, I will keep peace with
the tradition, and stick to the old
name. Intriguingly, it is said that
all the wisdom of Solomon is hid-
den in this knot. In a similar way,
the mediæval name for Solomon's
Knot, "The Emblem of Divine In-
scrutability", suggests that knots
were once contemplated as sym-

bols with religious or arcane philoso-
phical meanings.

For example, the way in which
the square, primary, and its centre,
secondary, provide the coordinates
for the division of the sides of the
square, tertiary, may have been
seen by early monks as a symbol
of tri-unity, three in one. The sing-
le square, 1x1 primary, spontane-
ously and simultaneously contains
a centre point, yet the square is a
unity, and the centre, 1x1 secondary,
is equally one in principle with the
square: they are as inseparable as
the circle and its centre. The centre
and the periphery of the square are
further related by the third, the
tertiary unit, the cross which passes

through the centre, the arms of which divide the sides of the square. So the wholeness of the unity is acted upon from within itself, by the action of its own centre, one divided by one, resulting in one. To the monks of early Christianity, the geometry of the square symbolized the creation of the manifold universe, and it was important to them to contemplate how the Two - the infinite and the finite, indeed all opposites - could be engendered by the One; the passage from One to Two must have been a reference of the symbol associated with 'Divine Inscrutability' and the epitome of wisdom, King Solomon. The passage from One to Two is symbolized by the grid: 1x1 primary, secondary, tertiary = 2x2.

fig. 5 The Three Grids of a Square.

a. The Square, or
 1 x 1 Primary Grid.
b. The Centre, or
 1 x 1 Secondary Grid.
c. The Mid-points of the Sides or
 1 x 1 Tertiary Grid.
d. The Tri-une, or Combination 1x1,
 is _at the same time_ a 2x2 primary,
 symbolizing passage from One to Two,
 while also symbolizing the Three-in-
 One.

fig. 6 The Development of the 2x2 Grid.

a. 1x1 Primary Grid.
The Primary Grid is
the first step in the de-
velopment of any knot
or plait: it defines the
corners of the square
area to be decorated.
Here, the square symbo-
lizes unity, origination.

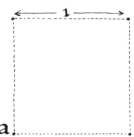

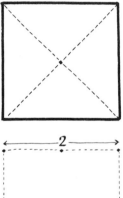

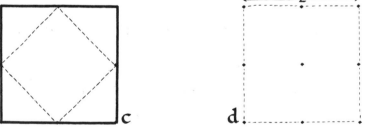

b. 1x1 Diagonal Cross, Secondary Grid: Centre.

c. 1x1 Tertiary Grid; Diamond: Turning Square.

d. Three grids together produce 2x2 Primary.

fig. 7　The 2×2 Grids; Primary, Secondary, & Tertiary.

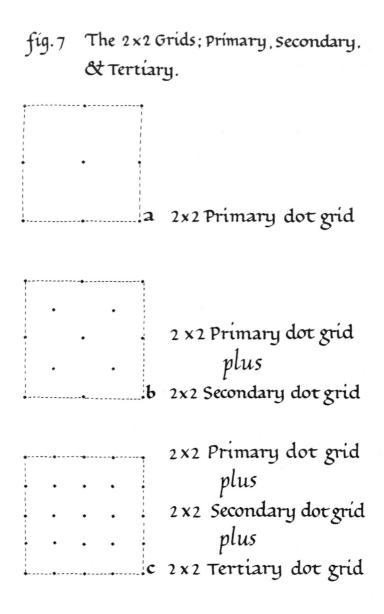

a　2×2 Primary dot grid

2×2 Primary dot grid
plus
b　2×2 Secondary dot grid

2×2 Primary dot grid
plus
2×2 Secondary dot grid
plus
c　2×2 Tertiary dot grid

fig. 8 Weaving the Line on the Tertiary Grid.

a. The tertiary grid
forms a diamond pattern;
there are 4 intersections,
each a tertiary grid dot. a.

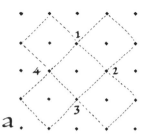

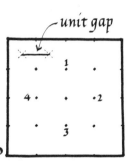

b. Start in the corner, a
line section from centre
to centre on the combina-
tion grid ~fig. 7c~ this b
gives the unit gap.

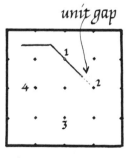

c. Continue the line
through the first tertiary
grid dot. Stop short of
the second tertiary grid c
dot, leaving a space equal to the unit gap.

fig.8 : continued...

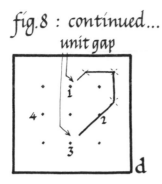

d. Start at 1, leave unit gap; turn corner; pass through intersection 2.

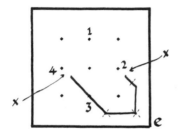

e. From under 2, leave gap; turn corner; pass through intersection.

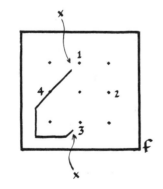

f. The final corner turn.

[22]

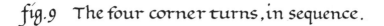

fig. 9 The four corner turns, in sequence.

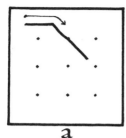

a

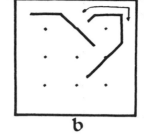

b

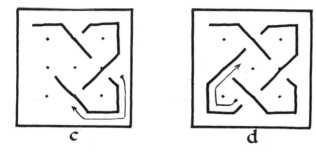

c d

The lines of this design may be drawn in order, clockwise. Do not forget the final touch, e.

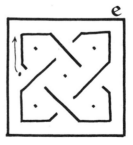

e

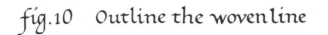

fig.10 Outline the woven line

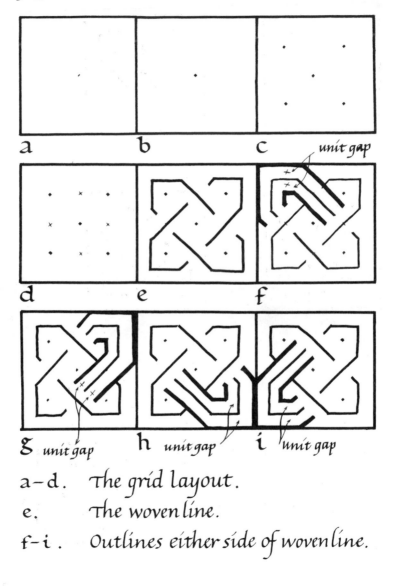

a b c unit gap

d e f

g unit gap h unit gap i unit gap

a–d. The grid layout.

e. The woven line.

f–i. Outlines either side of woven line.

fig. 11 Filling the Background.

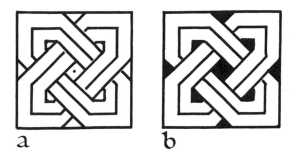

a b

a. King Solomon's Knot, woven centre-
line of the knot has been outlined segment
by segment.

b. The background has been inked in. This
completes King Solomon's Knot.
 Notice that the grid points have all dis-
appeared into the background of the knot.

 The end result is a broad-ribbon treatment.
The ribbon width here is as wide as it properly
should be, based on the maximum unit gap.

chapter III
the
foundation
Knot

HE FOUNDATION KNOT derives from Solomon's Knot. As Solomon's Knot is actually the simplest form of regular plaitwork, having a 2x2 grid base, the Foundation Knot is the simplest regular knot: the only regular knot that can be obtained from the 2x2 grid. So, it provides an example of how knotwork is derived from plaitwork, and for one who has followed the method of drawing Solomon's Knot so

far, the Foundation Knot will be easy to
master as it has so many steps in com~
mon with Solomon's.

The following figures show how to
draw the Foundation Knot; all you
need to draw with is a pen and paper,
no need to pencil sketch or erase. Start
big, with a square about the size of
the palm of your hand. Then, each
time you repeat the exercise, start
smaller, till you can draw the knot
the size of your little finger nail, or
as small as your pen or eye allows.

fig. 12 The Foundation Knot.

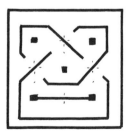 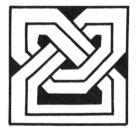

fig.13 Foundation Knot Construction

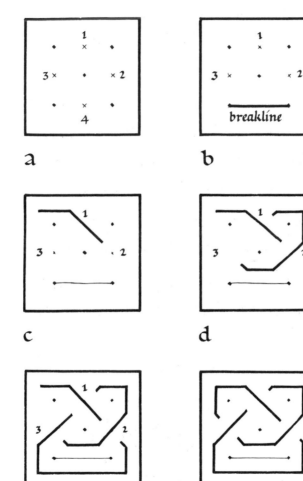

a

b

breakline

c

d

e

f

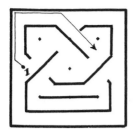

g

h

i

j

k

l

Outline each of the three line segments
with two outlines at a time, every time ⁖

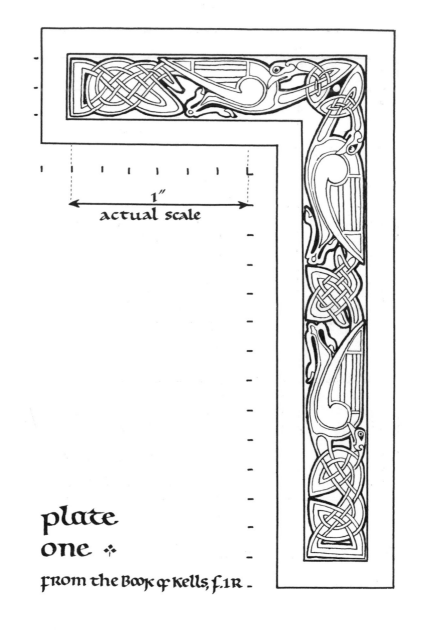

1"
actual scale

plate
one ✦
from the Book of Kells, f.1R

Chapter IV
Extending
Knots & the
Josephine Knot

ING Solomon's Knot oc-
cupies a square contain-
ing a dot grid 2 units
across and 2 down. To extend this
knot, let us first double it. Two u-
nits will fill a box containing four
spaces across and two down, that is,
a 4 x 2 dot grid. The result is what
I call 4x2 plait. Its construction is
illustrated in the following figures.

fig. 14. Extending the grid to 4x2.

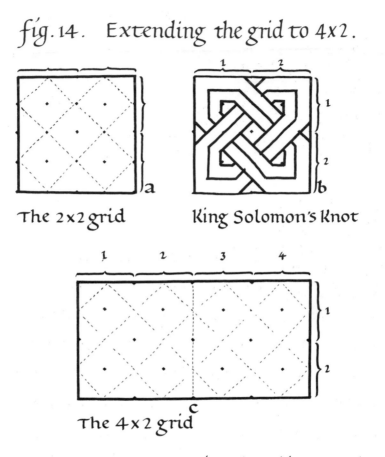

The 2x2 grid

King Solomon's Knot

The 4x2 grid

As you can see by comparing the grids at a and c, the 4x2 grid is double the 2x2.

Two 2x2's placed side by side make up the 4x2

2 x 2 + 2 x 2 = 4 x 2

fig. 15 The 4x2 Plait Construction

a

2x1 Primary Grid
two squares

b

2x1 Secondary
two midpoints

c

2x1 Pri., sec., & ter.,
= 4x2 pri.

d

4 x 2 pri. & sec.

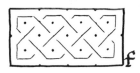
e

4x2 pri. & sec. & ter.

f

The 4x2 Tertiary Grid
provides the crossover
points for weaving.

fig. 15, continued.

g

Outline each line
segment with a
double outline

h

i

j

Fill in the back-
ground.

This design was drawn entirely with an
italic nib, and Indian ink, and ruler edge.

 ust as the Four·by·Two Plait may be viewed as a pair of Solomon's Knots side by side, so a pair of Foundation Knots may be made into a Four·by·two Knot, fig. 16.

fig. 16 The Four·by·Two Knot

The larger dots are primary & secondary. Break lines go on Sec. grid.

Compare with fig. 15, f.

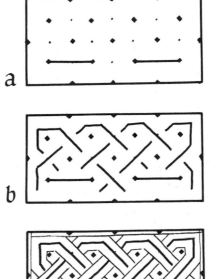

fig. 17. Josephine Knot.

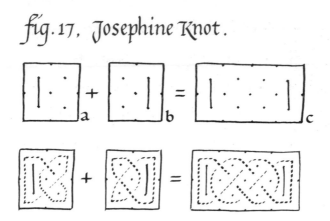

As here, the Foundation Knot may be turned sideways, a & b, using vertical breaklines; when these two breaks are put into the 4x2 grid, as here, c, the result is the Josephine Knot.

OSEPHINE was Napoleon Bonaparte's empress, and was a favorite of the seamen of those days, or so we might guess, for this is a knot that is traditional to sailors. It is also a Celtic knot that

was popular over a thousand years ago, and still is, among Celtic artists.

The Josephine Knot is also a lover's knot. Two intertwined links make this whole pattern.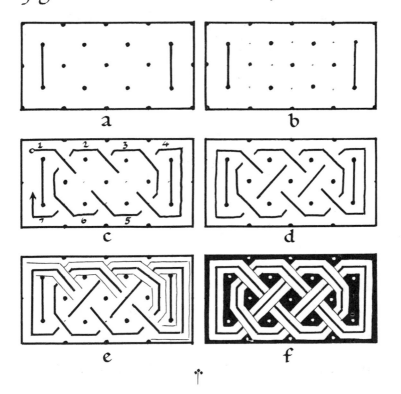

fig.18 Construction of Josephine Knot.

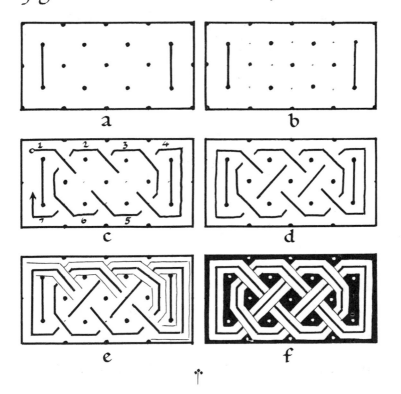

a

b

c

d

e

f

fig. 19 Repeat border of Josephine Knots

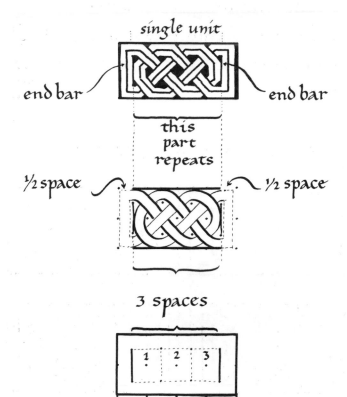

single unit

end bar — — end bar

this part repeats

½ space — — ½ space

3 spaces

1 2 3

1 2 3 4

Josephine's knot is actually three spaces wide, on the secondary grid, if you count between the breaklines. The single unit has two bars splicing together the loose ends.

fig. 20 Josephine knot border, 2 units.

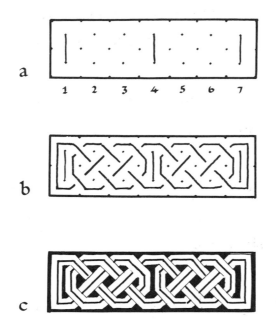

a

1 2 3 4 5 6 7

b

c

The repeat is 3 spaces, 2 units is 6.
To close the ends, ½ space at either end.
Thus, total of spaces for 2 units is 7.
— here, 3 N + 1 (where N = 2) = 7 —
The rule is: (the number of spaces to a repeat)
by N (the number of repeats) plus 1 (½ + ½).

fig. 21 Josephine Knot Border, 3 units.

Q. How many spaces are required to
 fit 3 units of Josephine's Knot?

A. Let N equal the number of repeats
 required, then $N = 3$.

 Let X equal the number of spaces
 required by the repeating part of
 the knot.

 Since the single unit requires bars,
 one at each end, and each one is ½ a
 space, then the border will need
 $XN + 1$ spaces all told.
 $X = 3$; $N = 3$. Therefore $XN + 1 = 10$.
 10 spaces are required by a 3 unit
 border of Josephine Knots.

fig. 21 , continued...

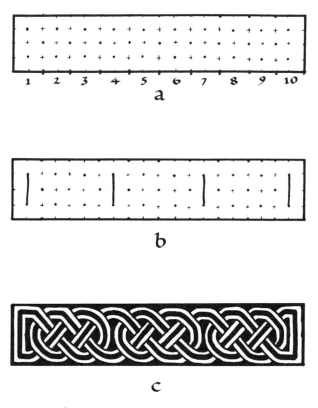

a

b

c

a & b laid out on a ruled square grid
with medium italic nib in holder.
c drawn directly on grid b; centre line
"Speedball B4" nib; outline, "Speedball FB 6."

[4 1]

fig.22 Ten Square Panel of Josephine's Knots

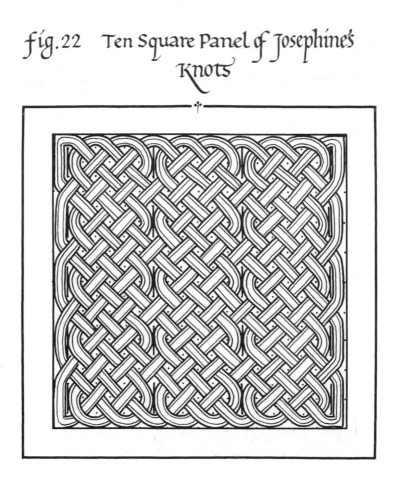

the background is left open so you
can see the construction of primary &
secondary grid dots, & breaklines.

chapter v
Building a
a panel

MALL KNOTS are ea-
sily done on a freehand
drawn dot grid, but for
a larger panel, or where
accuracy is desired, a geometric lay-
out is good to know how to do. We
have been accustomed to a square
grid, divided in two, four, eight, etc.
We can divide a line in two, surely,
by eye. So we can build an accurate
grid by halfing, quartering and so on
indefinitely. But a five-fold grid

is another matter. It is not so easy to draw a five-by-five grid on large scale, by eye. There is a simple method from the Book of Lindisfarne, however. by which a five-square grid may be produced, using traditional geometry.

fig. 23 Construction of Octagon Star in Square

Given:

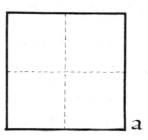

a

a square divided into 4. Find the centre first, then divide the sides...

b

With a pencil, join the midpoint of one side to opposite corners.

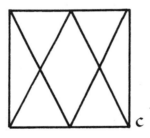

c

Repeat from the opposite side.

Complete on all sides.

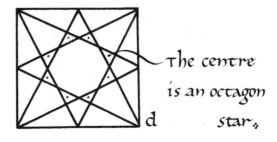

d

The centre is an octagon star.

[45]

fig. 24 Derivation of Five-fold Grid from Octagon Star.

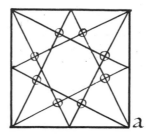

a

These eight points, when joined, divide the square into five, thus:

b

c

d

e

fig.25. Doubling the Five-by-Five Grid
by means of the Octagon Star.

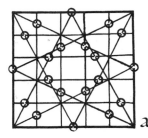

These twenty points split the 5^2 grid into
a 10^2 grid. Note: compare with fig.24,e.
The star that produces the 5^2 also cuts it
at the points which produce the 10^2, f.25,a.

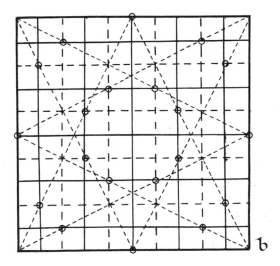

fig. 26 Derivation of 10² by Octagon Star & 2² Diagonal Grid

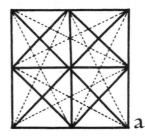

a: the 2² diagonal grid, (and the 2² primary).

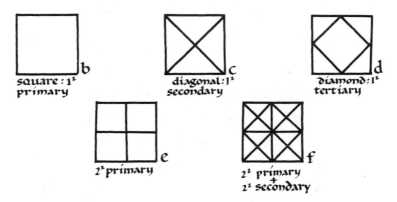

square : 1²
primary

diagonal : 1²
secondary

diamond : 1²
tertiary

2² primary

2² primary
+
2² secondary

1² primary. b, + 1² secondary, c, + 1² tertiary, d
= 2² primary, e. Combined b, c, d, e = f.

f may also be read as 2² primary + secondary.

Square = prim., Diagonal = sec., Diamond = tert.

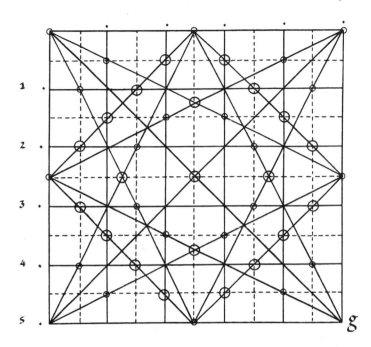

g

The 2x2 grid at *a*, opposite page, is already
implied in the diagonal, vertical & horizontal
axes of the octagon star. The star produces a
5x5 grid, *f.24*, and splits this into 10x10.
By using the 2^2 grid, *f.26a*, we generate so
many more divisions of the 5x5 grid that
the 10^2 may be ruled with more precision.

fig. 27. Five-squared dot grids.

a

b

c

d

f

e

using the star, a, produce a 5^2 grid. A
sharp, hard pencil - 6H - is ideal. On the pen-
cilled grid, b, ink the square dot grid, d;
that is the 5^2 primary. Mark in ink the centre
of each cell, e; 5^2 secondary. Ink the tertiary, f.

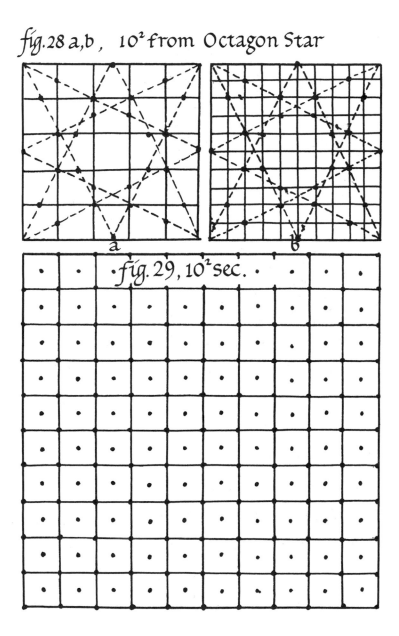

*fig.*28 a,b , 10² from Octagon Star

a

b

·*fig.*29, 10² sec.·

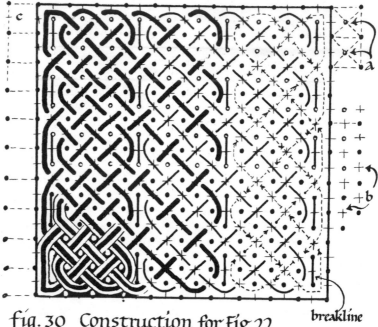

fig. 30 Construction for Fig. 22. breakline

On the 10² secondary grid are placed the
breaklines for the pattern.

Next, pencil the tertiary grid, here marked
as crosses, b.

Now weave the line of the knot, passing over
& under the intersection points, i.e. the
pencilled tertiary grid. Note: the primary
counts the spaces; secondary = breaks; tert. = knot.

fig. 31 Construction of panel, fig. 32,
10² panel of Josephine Knots, variation no. 2.
variation no. 1, page 42.

Here the vertical breaklines, on the secondary
grid, are the same as on opposite page. However,
breaklines may be laid on the primary grid, to
distinguish units of repeat patterns, as is
the case here : horizontal breaks on primary ...

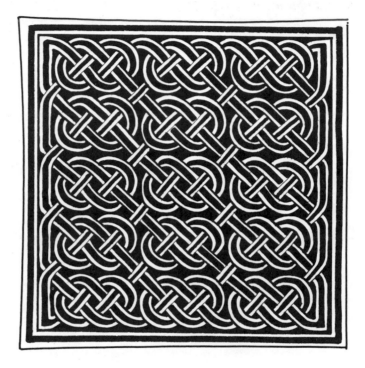

fig 32

A.M. June 5 '86

chapter VI
Analysis of
plaitwork

 N REPEATING a
knot we use
each of the three grids
in different ways.
So, a border of Josephine knots, p. 41,
involves counting separate spacings
on the secondary & primary grids.
A border of Josephines involving
the formula on p. 40 is obvious at a
glance as a series of units. But in
the vertical repeat of the border ~
p. 42 ~ the knot is lost.

The knot unit in horizontal repeat
is defined well enough by the breaks
on the secondary grid, but to keep it
as well defined in a panel, as on p.54,
we must use primary grid, horizont-
al breaks, p.53. This shows the impor-
tance of being able to distinguish bet-
ween one dot and another. Take, for
example, the square dot grid on p.58,
f.34, c. Pick any dot on the 5^2 combi-
nation and see if you can tell if it
is a primary, secondary or tertiary
grid dot. If you have been following
the figures to this point, you will be
able to do this.

You will also have realised that
when drawing the lines of the inter-
lace, the tertiary grid dots become
intersection points which are swal-
lowed by the cross over, f.33, a.

fig. 33 Three Grid & Two Grid method.

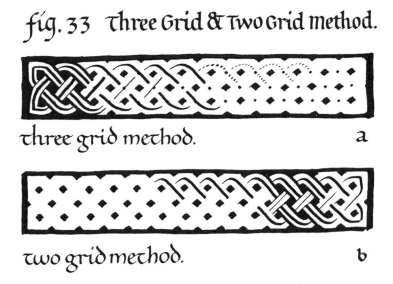

three grid method. a

two grid method. b

However, this method requires a
centreline thicker than the tertiary
dot, or the dot will show through,
and spoil the appearance. It is better
to draw the line by the two grid meth-
od, to learn to see the path of the
tertiary grid as the white path be-
tween the domino-spots of the
primary-secondary dot grid.

fig. 34 Corner turn & Edge bend

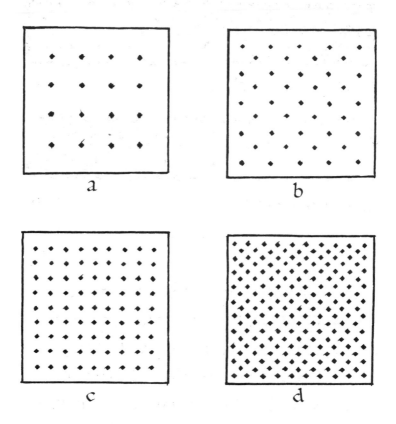

a

b

c

d

a: five by five primary dot grid.

b: five by five secondary dot grid
plus five by five primary dot grid.

c: five by five primary dot grid, plus five by five secondary dot grid, plus five by five tertiary ...

which is also ten by ten primary dot grid.

This ten by ten square grid of dots now becomes the basis of the next stage...

d: ten by ten primary dot grid plus ten by ten secondary dot grid.

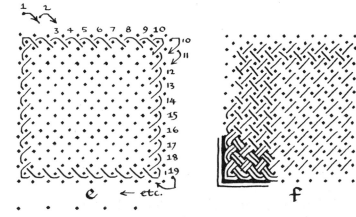

e: weave the centre line thus.

f: complete weave; outline; fill in.

fig.35 Five by Five Plaitwork Panel

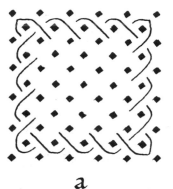
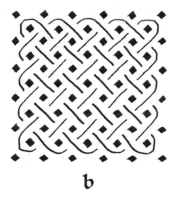

a b

c d

a. Weaving the corners and edges.
b. Weaving the straight strands.
c. The four corner elements.
d. The four side-edge elements.

fig.36 Chequer Effect of straight strands.

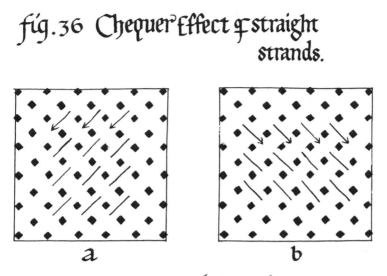

a b

Straight strokes cross diamonds:

a. Straight strokes, right to left.
b. Straight strokes, left to right.
c,d Strokes correspond to chequer.

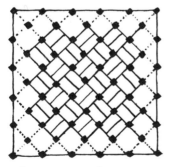

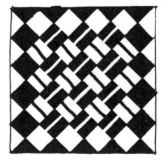

d the grid forms a c chequer board

Fig.37 First stroke-corner Triangle & Diamond

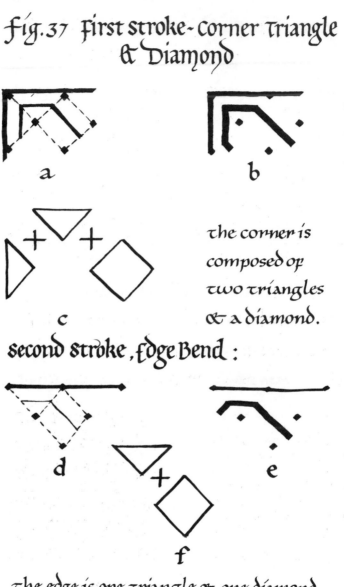

a

b

c

the corner is composed of two triangles & a diamond.

second stroke, edge Bend:

d

e

f

the edge is one triangle & one diamond.

fig. 38 Second Stroke, Edge Triangle & Diamond

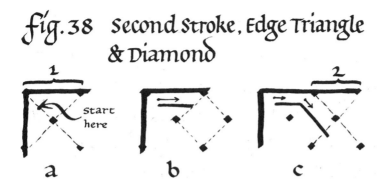

a b c

Starting at the top right-hand corner, on the diagonal axis, a; cross the triangle, b. This cuts the side common to both triangle & diamond. The next move is to cross the diamond. Start the second stroke in tri-

~ remaining edge strokes ~

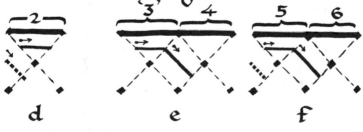

d e f

angle 2, d; repeat stroke to left~

hand corner. Note the triangle is one space, or primary grid unit along the edge. The corner at top right of the 10^2 plait will be the tenth triangle. Along the edge, each stroke passes through a triangle, turns around the secondary grid point & through the diamond. This holds true for all edge bends. The corner turn, however, differs from that again, for it involves two triangles.

fig. 39

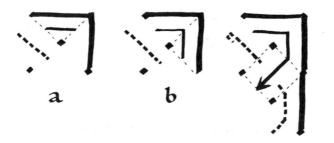

a b c

fig 40 Diagonal Opposition of Straight Strokes.

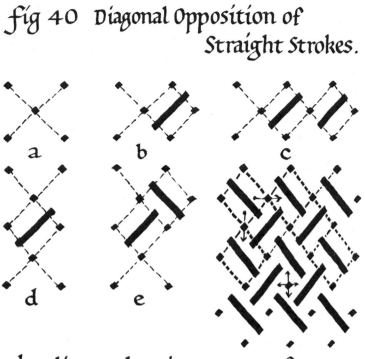

a b c

d e

f

the diamonds point-to-
point, across, c, or down, d,
are identical.

Diamonds side-to-side are op-
posed, on the diagonal directions,
e. You cannot cross more than
one diamond at a time in any direction.

At this stage, we continue to use the tertiary grid in the build up of the dot grid. However, we will only use the primary and secondary grid for the interlacing, p. 57. This is a new method, and so it has been introduced in the present analysis of plaitwork, to practise drawing plaitwork without drawing the tertiary grid intersection points at all. As we shall see later, once you can do this, it will be possible to explore a variety of treatments of plaits and knots, by the two-grid method.

 With this method our perception changes from one of connecting dots to one of dividing triangles and diamonds: the dividing of surface by line.

fig 41 square plait, Dot & line

a. 2 x 2 square plait.

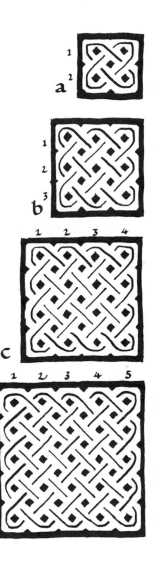

❖

~ℬ two links.

b. 3 x 3 square plait.

❖

~ℬ three links.

c. 4 x 4 square plait.

❖

~ℬ four links.

d. 5 x 5 square plait.

~ℬ count the links.

fig. 42 square plait; outline & fill in.

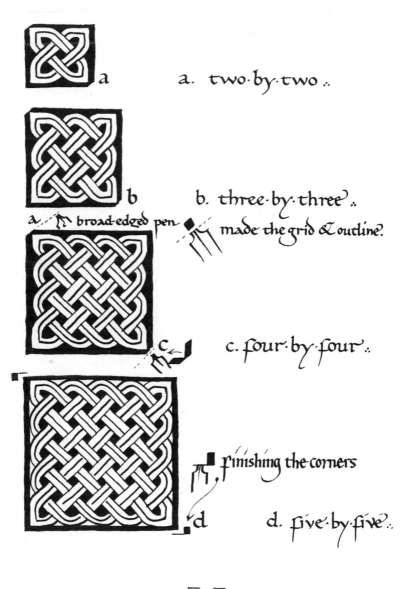

a. two · by · two ∴

b. three · by · three ∴

a. broad-edged pen made the grid & outline.

c. four · by · four ∴

finishing the corners

d. five · by · five ∴

chapter VII
plaitwork
to practise

LAITWORK as well as knotwork may be continuous or discontinuous; that is, made up of a single, continuous, endless path, or of more than one path, several interlinked circuits. Square plaits have as many links as spaces along the side, figs.41,42. Add a row, and the plait becomes a

fig.43 Rectangular plait: dot & line

continuous path rec-
tangle, as you can see
here, fig.43,44.

a

These plaits are
drawn with a
broad-edged pen.

b

c

d

fig.44 Rectangular Plait: Outline & fill

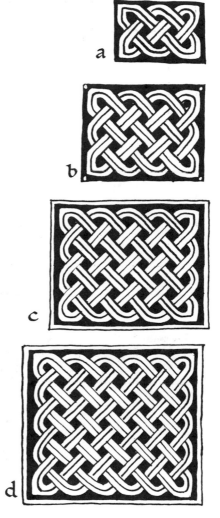

a

b

c

d

The rule is: numbers with no common factor produce an endless line plait.

a: 3x2 ; b: 4x3; c: 5x4; d: 6x5.

fig.45 10² Cross: Primary Grid

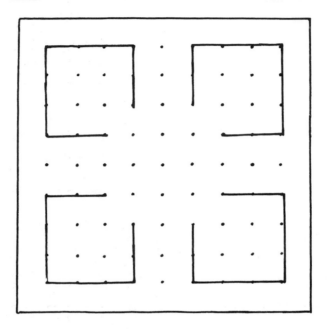

The Cross Panel

fig.46 10² cross: secondary Grid

Carpet-Page design

figs.46 – 51.

fig.47 10² cross ∴ background panels

A show piece of the art of de-
coration, the carpet-page design,
so-called by virtue of its resemblance
to the design of a persian carpet, often

fig.48 10² Cross ∴ Foreground

takes the form of a cross panel in the
decorated Gospel books such as Durrow,
Lichfield (a.k.a Chad), Lindisfarne &
Kells. In Durrow, plaitwork is used
to decorate the panel.

fig.49 20² Cross : primary grid

Figs. 45,46,47,48 : a simple exercise, a 10² cross with plaitwork inlaid background, 47, or reverse form, 48; to combine both forms, a separating band or

fig. 50 20² Cross: Secondary Grid

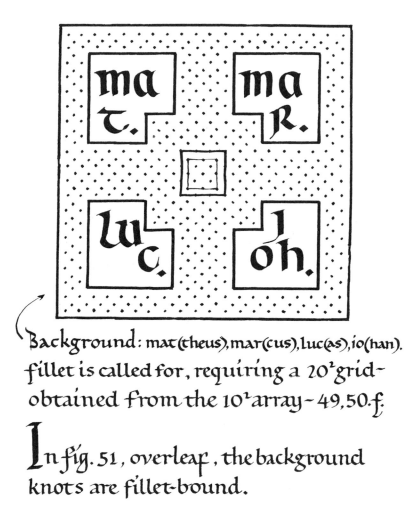

Background: mat (theus), mar (cus), luc (as), io (han).
fillet is called for, requiring a 20²grid-
obtained from the 10²array - 49,50.f.

In fig. 51, overleaf, the background
knots are fillet-bound.

Fig.51 Twenty square plaitwork Cross.

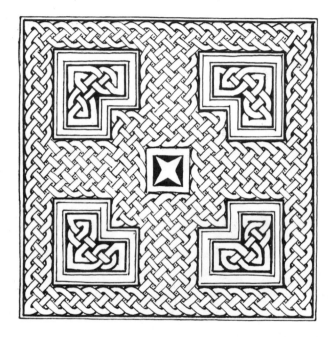

drawn with Canada Goose quill.

Aidan
June 9 '86

chapter VIII
Division of
a square

quills & lampblack ink ·

HE GREAT FULL-LENGTH
decorated pages are
constructed on grids
built geometrically,
based on a square. The first step is
to divide the square. Two ways are
shown, figs. 55 & 56. The latter follows
more directly from the construction of a
square, fig. 53, though both are canonical.
Less satisfactory, because less symbolical-
ly intelligible, therefore non-canonical,
is fig. 54, though it is a sensible method.

fig. 52 ✠ Cross Panel of St. Chad ✠

⁘ the preliminary layout ⁘

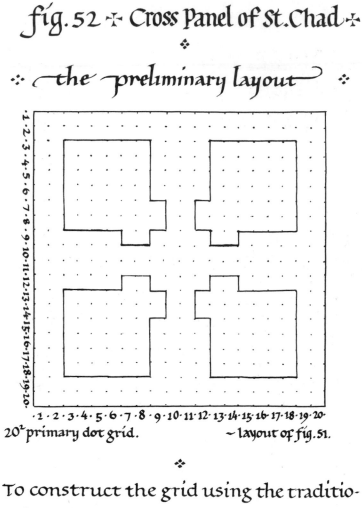

20² primary dot grid. ~ layout of fig. 51.

❖

To construct the grid using the traditional method, compasses & straight edge alone, begin with a square, fig. 52, and then a 5² grid, as at fig. 24.

fig. 53 Canonical Construction of the square ⁘

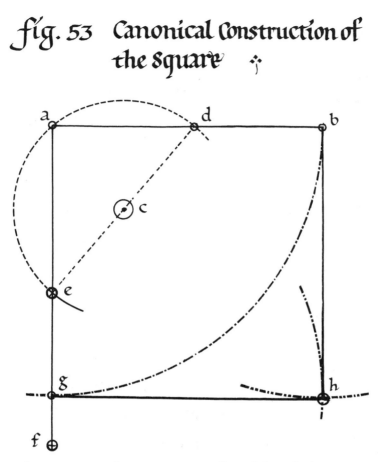

Given a length, ab, to be the side of the square, place point of compasses below the line ab, and with radius ac, cut ab at point d. Join d through c to cut the curve at e. Produce perpendicular to f.

fig.53, continued:

Having produced the corner, baf, now describe the arc, radius ab, cutting af at g.

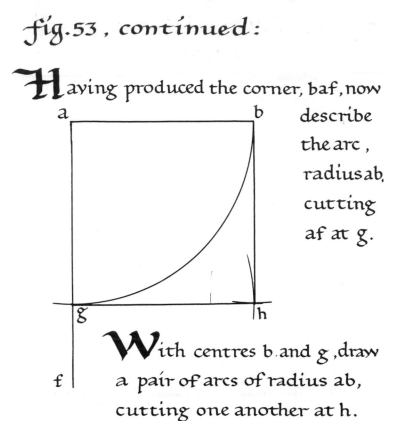

With centres b and g, draw a pair of arcs of radius ab, cutting one another at h.

This done, rule up the square, abhg, in ink, and erase the fine-pencilled construction.

The next step is to produce the vertical cross, the Trinity Grid, f.3a, p.10.

fig. 54 The Quartering of the Square, by the vertical cross.

Find the centre of the square, by means of the diagonal cross, e.

With centres c, d, radius c,e, produce the arcs ef.

Join fe, and produce to cut ab at g. This is the mid-point of ab. Also, fg bisects cd at h.

With centres cd, radius ch, produce arcs to bisect ac at j, and bd at i. Thus is the vertical cross made.

fig. 55 The Division of the
 Square: Canonical
 ❖ Method~ ❖

As the line
a b is the
 unit with
 which we
 begin, we
 can best de-
 monstrate
the division of unity by unity thus:
let the line **ab** be 1, then the square
is 1x1, which is one. Now the divis-
of the square is accomplished within
the square by the diagonal **ad** or **bc**,
so that **abc** equals **dcb**.

While this divides the unity
 of the square, it does not di-

vide the side; to achieve the division
of side by diagonal, as f.54, takes us out-
side the square. The method here is ca-
nonical, simpler, internal; the sides
are used to divide the sides themselves,
$1 \div 1 = 1$, thus main-
taining unity.

fig.55:
centres c, d,
rad.ca, find f;
join ef, and
produce to h, i

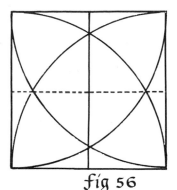

fig 56

This method uses the sides and diago-
nals. Fig. 56 uses sides as radii only to
divide the square. Also, it establishes
the centre in a way that uses only
the square, rather than diagonal cross.
Both methods are canonical symbols
of the division of Unity, the Primal
Act of the Principle of Creation.

[85]

Given the 2^2, we construct a 5^2, which splits into 10^2; divide and quarter this, i.e. 10^2 primary, secondary and tertiary, to arrive at the 20^2, and hence lay out the grid for the cross. Now we are ready to decorate the panel: first with plaitwork, as in fig. 57.

fig. 57 3^2 Knot as Panel :

$6^2 = 3^2$ PRI. ◆

$+ 3^2$ SEC. ■

$+ 3^2$ TER: -|-

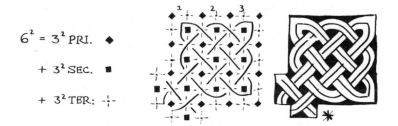

The panel is a square, 6^2 on the 20^2, 3^2 – pri, sec, ter – on the 10^2. Obviously, the 3^2 does not fit, being truncated.*

fig. 58 6^2 knot as panel :

OMIT BREAK HERE

You can deduce from this plan that the square knot is a symmetrical pattern; in fact, continu- ous. But, with the fishtail stepped onto the corner, a break may be dropped and continuity be preserved; either way is acceptable. Engineering a continuous path is a challenge of skill, though. This one will fit Chad's Cross.

original design,
† ⊿⌁'86

$[87]$

fig. 59　Full-length carpet-page

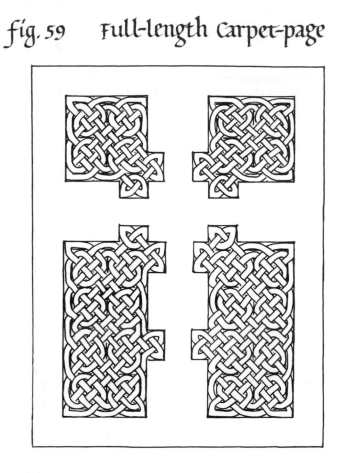

Knot panels based on fig. 58 ∴
With or without breakline omission,
fig. 58 is continuous. The panel at
lower left uses all the breaks.

fig. 60 : Two Plans :

a: Plan of fig. 59.
b: Plan of fig. 61.

fig.61　Cross Carpet-Page : 32x44 grid✝

steel nibs & gouache black .

mcmlxxxvi.vi.xv.

Aidan ✝

chapter ix
plaitwork panel
from the
Book of durrow

 URROW is the earliest
of the fully illumin-
ated Gospel Books of
Celtic Art. Of special
interest is the open-
ing page, folio 1v, the carpet page with
two-armed cross. The cross-panel,
framed in knots, is itself inlaid with
plaitwork; i.e., it has no breaklines,
though crosslet inserts break the plait-
work. let us examine this great design

fig. 62　Crosslet Diaper: 18 x 24 grid

fig. 63 Double-Cross from Diaper

primary grid 9/12; split to 18/24. = □ = ∶ ∶

primary 18/24 ; secondary 18/24. ⊠ = ∴

Cross & crosslets laid on secondary grid, 18/24.

fig. 64 Celtic Crosslet: Knot & Spiral:

the crosslet is on a smaller grid than
the surrounding knot. The crosslet
knot construction is shown on
page 99, f. 70.

fig. 65 : Crosslet with key pattern :

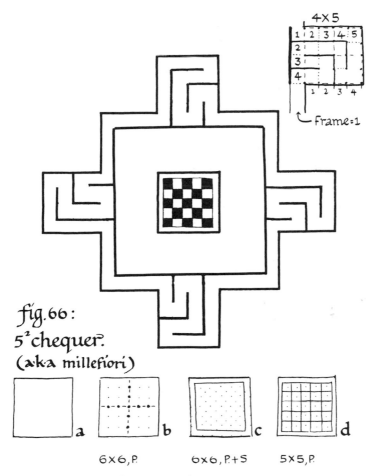

4×5

Frame = 1

fig. 66 :
5² chequer.
(aka millefiori)

a

b

c

d

6×6, P. 6×6, P.+S 5×5, P.

The centre chequer is a 5², surrounded
by a frame ½² wide; i.e., 5² primary, 6² secondary.

fig. 67 : Knotwork Crosslet : breakplan

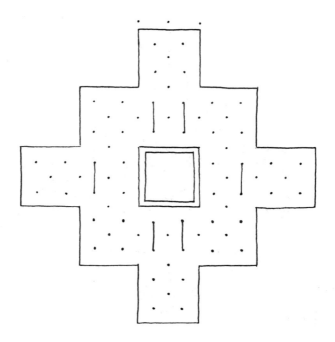

fig. 68 : Knotwork Crosslet.

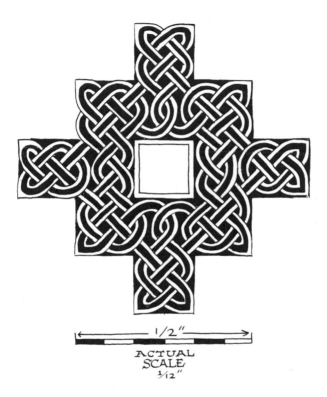

1/2"

ACTUAL
SCALE
1/12"

The knot is not continuous.

fig. 69 : Swastika -Tau -Fret : Square :

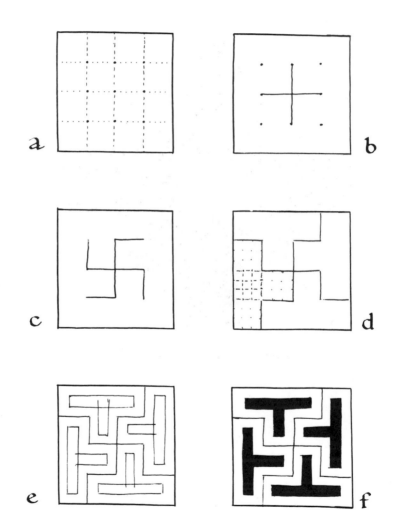

a b

c d

e f

fig. 70 : knot & spiral construction of crosslet, fig. 64.

~: see page 94 :~

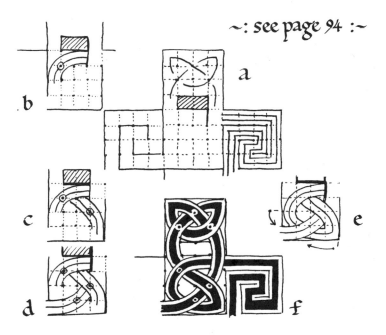

This is a combination of two knots, a regular Foundation Knot, a, and an irregular knot, b~e, separated by a box break, shaded. The odd knot crosses on a secondary grid dot, b.

[99]

fig. 71 Durrow Cross Panel :
— vertical knot border —

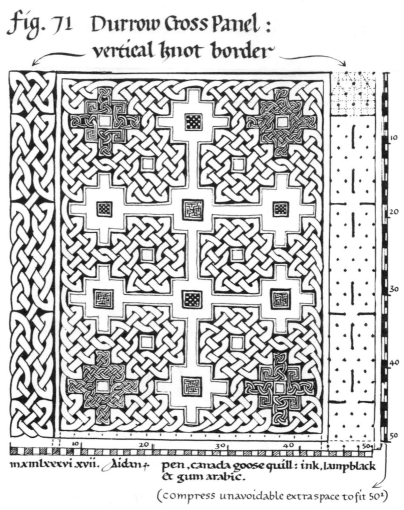

mxmlxxxvi.xvii. ꝺidan꜔ pen , canada goose quill : ink , lampblack
& gum arabic.

(compress unavoidable extra space to fit 50²)

Compare the cross panel above with plan on p. 93.
On the right here is the breakplan for the knot
strip to the left. The whole design fits a 50² grid.

[100]

fig. 72 Step pattern from Sutton Hoo.

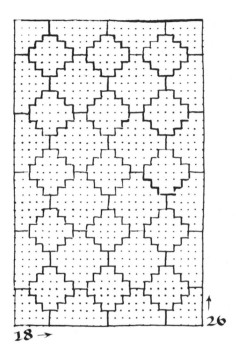

18 → 26 ↑

This pattern from the Saxon Ship Burial of Sutton Hoo. England may be the source of the Durrow carpet page. The resemb~lance is more than superficial. If the step pattern be outlined on the secondary grid. the resultant cells conform exactly to the grids required for the Durrow crosslets, see f. 62,63,71,73.

fig. 73 Sutton Hoo & Durrow in combination.

Both the Durrow crosslets fit the step pattern on the secondary grid.

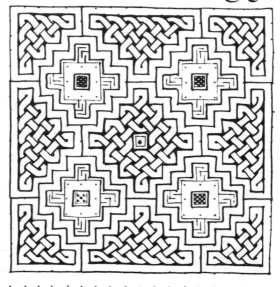

The edge of this panel is 18 spaces. This is the primary grid, on which is laid a portion of the Sutton Hoo step pattern, page 101. The step pattern outlined & inlined on the secondary gives Durrow.

chapter x
spiral knots

PIRAL knots turn up here and there in knot designs in Celtic manuscripts, carved stones, and metal work. Usually they have been explained as being e-volved from putting a circle on a diagonal cross, or concentric circles on parallel dia-gonals, and breaking the circle to join a diagonal. Over leaf, you can see a spiral knot produced in that way.

fig . 74 Spiral Knot;
 Line method.

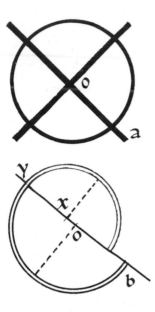

a. Wheel cross: circle
 & diagonals of a
 square.

b. Spiral: 2 semi-
 circles, centres O,X;
 joined at Y.

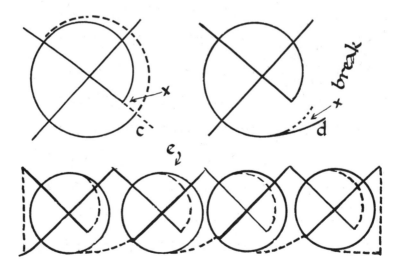

fig. 75 Spiral knot:
single unit to fill a
square; pencil-erase
method.

a

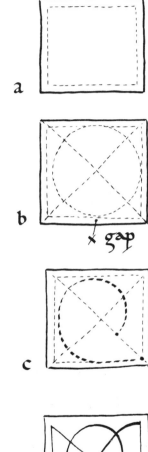

b

✗ gap

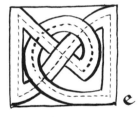

e

c

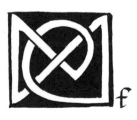

f

d

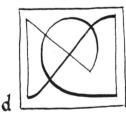

Pencil, a–d; ink weave, e; erase pencil, f.

fig.76　Spiral knot ~ Four unit Border:

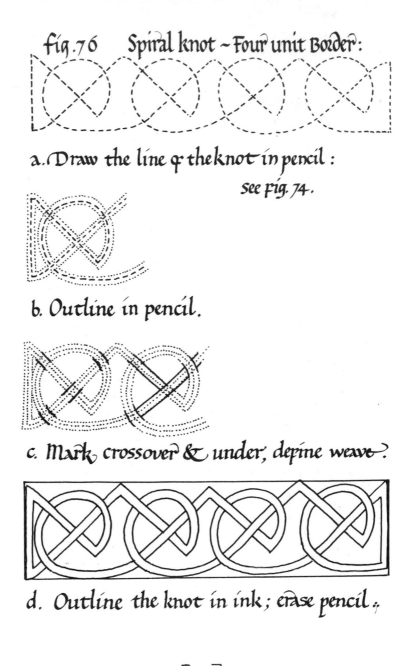

a. Draw the line of the knot in pencil :
 see Fig. 74.

b. Outline in pencil.

c. Mark crossover & under; define weave.

d. Outline the knot in ink; erase pencil.

[106]

fig. 77 Spiral knots ; 2 Units , mirrored ;

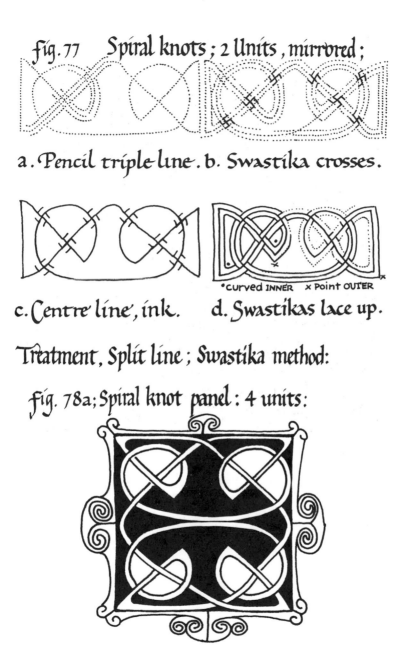

a. Pencil triple line. b. Swastika crosses.

•curved INNER x Point OUTER

c. Centre line, ink. d. Swastikas lace up.

Treatment, Split line ; Swastika method:

fig. 78a; Spiral knot panel : 4 units :

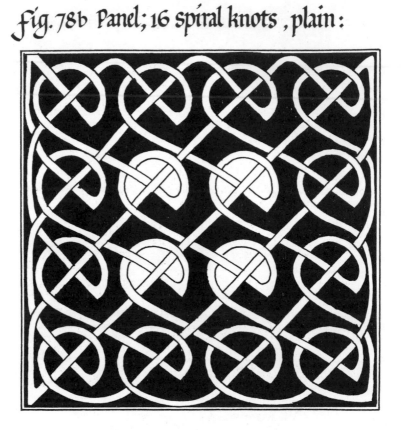

The panel is developed from the four unit
border, as above on page 106, fig. 76.

fig.79 Same; with split ribbon openwork:

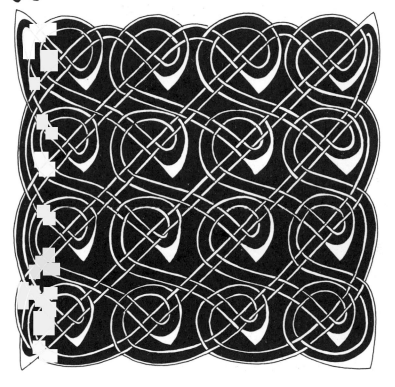

In figure 77, the path of the knot is split
by the "swastika" method; here, the
split ribbon work can only be produced
by the pencil~erase method, which
gives this lacy openwork effect.

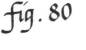 *fig. 80* Openwork Split Ribbon; pencil-erase method

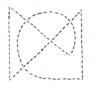

a

Lightly pencil the centre line.

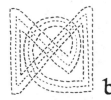

b

Slightly more heavily, pencil either side of centre line.

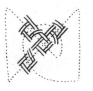

c

Weave outlines only; ink-lines are pencil-line thickness apart;

d

erase pencil when weaving is completed; ink in with brush.

— This is most effective done very small scale.

fig. 81 Spiral knot – Two unit variation; from Tara Brooch pin head:

a

b

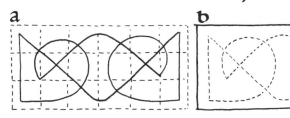

This arrangement, spirals back-to-back:

c

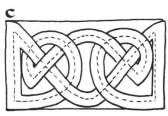

d

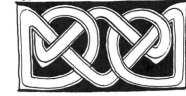

a. The knotline.
b. Pencil it in.
c. Outline and
weave. This is broad band style.
d. Broad band may be given a fine
inline which may be coloured in:

COLOUR
THE
CENTRE
PORTION (SHADED)

fig. 82 Spiral Knot Panel; four units, back-to-back; from bone trial piece, Lagore Crannog.

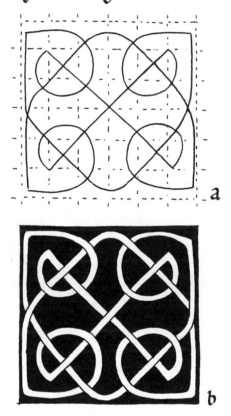

a

b

fig. 83 Dot-and-breakline Grid for Lagore Crannog knot:

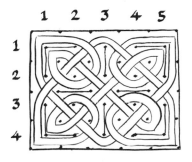

The primary grid is 5 spaces across, & 4 spaces down.

Fig. 84,a. Bird with Spiral Knot Neck, from Book of Kells, folio 2 R:

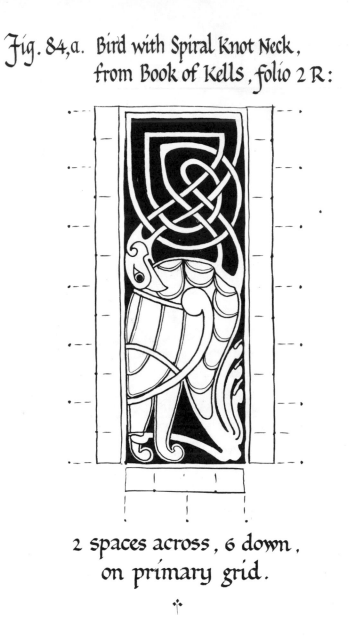

2 spaces across, 6 down, on primary grid.

✣

fig 84,b. Kells Bird with Spiral knot neck; canonical plan & variant:

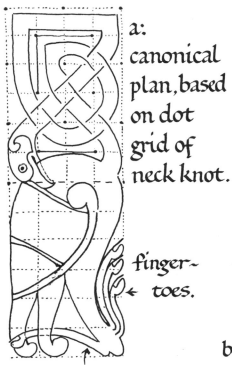

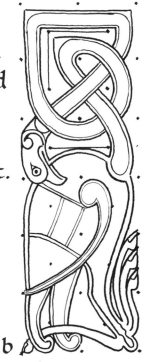

a:
canonical
plan, based
on dot
grid of
neck knot.

finger-
← toes.

thumb-toe.
Body inlines
& wing treatment
may be varied
freely ;-

b

Here neck has
broad ribbon
treatment;
thumb-toe
weave reversed.

fig. 85　Spiral Knot panel,
　　　　Ardagh Chalice layout:

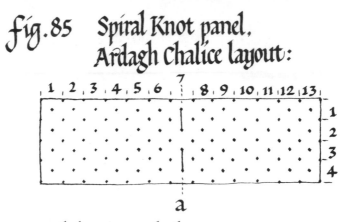

For this panel, lay out a square
grid of dots 13 across and 4 down;
lay the centre points of each of
the square cells, thus making
the *secondary grid*.

As this is an odd number of
spaces on the primary grid, the
vertical axis of symmetry falls
on the secondary grid, a, above.

Lay the first break lines on the axis;

[116]

fig. 86 Ardagh Chalice Panel; breaklines:

starting from the centre, repeat the
pairs of secondary grid breaklines
to each end, leaving two spaces be-
tween each pair:

Next, arrange horizontal breaks thus:
(note the horizontal axis*on primary)
grid.

fig. 87 Ardagh Chalice Spiral Panel

The panel reflects the solar cycle

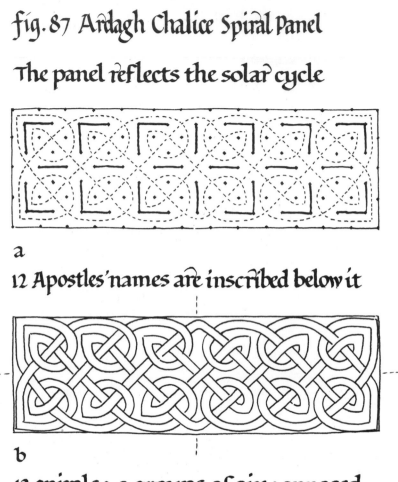

a

12 Apostles' names are inscribed below it

b

12 spirals; 2 groups of six; opposed on either arm of cross horizontal or vertical, "X" in centre; 4 groups of three : solstice & equinoctial numbers.

fig.88　Ardagh Brooch; spiral knots;
row of three:

dots & breaks;　　a　　　　　pencil..

breaks
&
dots;　　　　　b　　　　　ink..

pencil;　　　　c　　　　　line..

pencil;　　　　d　　　　　outline;

ink;　　　　　e　　　　　weave
&
fill in.

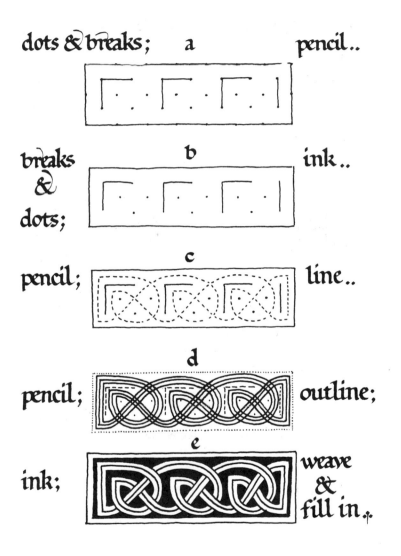

fig. 89

a,b,c : from Large Ardagh brooch.
d: from silver gilt
brooch, Cavan.

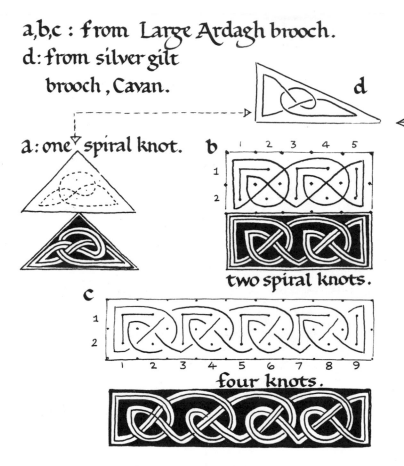

d

a: one spiral knot. **b**

two spiral knots.

c

four knots.

Each repeat unit = 2 spaces wide.
Let n = number of repeat units;

fig. 90

a,b : Ardagh brooch.

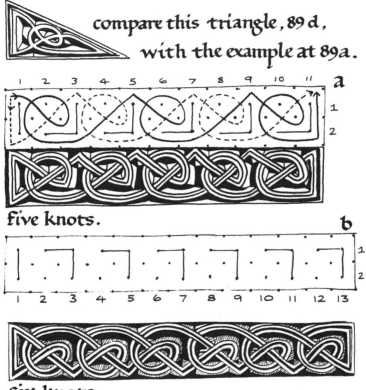

compare this triangle, 89 d,
with the example at 89 a.

a

five knots.

b

six knots.

total number of spaces = 2 n + 1.
Thus, 4 knots = 9 ; 6 knots = 13.

[121]

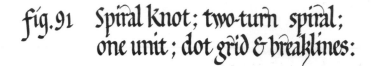

fig. 91 Spiral Knot; two-turn spiral; one unit; dot grid & breaklines:

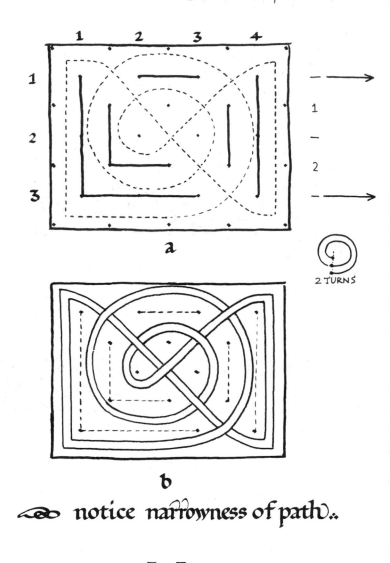

a

2 TURNS

b

∞ notice narrowness of path..

fig. 92 Compare one- and two-turn spiral knot grids:

Compare figs 91 & 92:

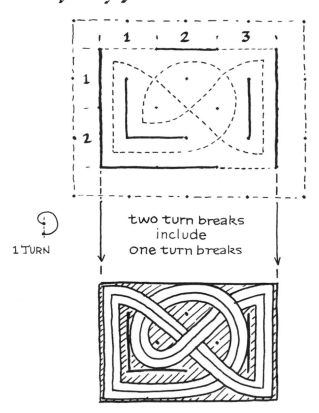

1 TURN

two turn breaks
include
one turn breaks

although same scale, fewer breaks & less curvature allow path thickness∴

fig. 93 Two-Turn spiral knots, from
 Lagore Crannog; row of 2 units:

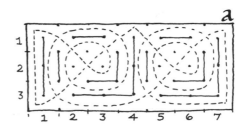

The dots
were drilled
or pierced
in bone,
& the
break lines
incised to
form the
knot.

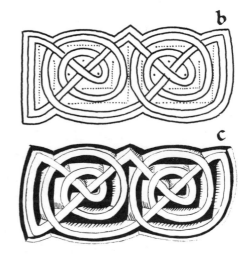

In all the spirals from Lagore bone &
Ardagh brooch the proportions of path
width & flattened curve mean dot
grids were used.

[124]

fig. 94 Spiral knots; Ardagh Brooch; two turns; row of three—:

a

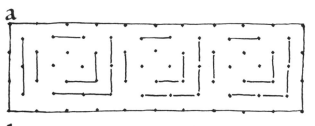

b

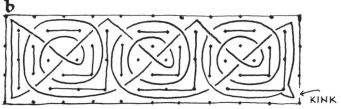

KINK

c Plan for chip carving:

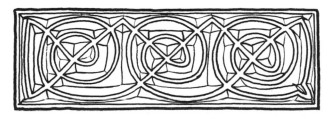

The flattening of the spirals as well as the corner kink indicate that the worker followed the canonical grid⸵

fig. 95 Spiral panel ; 4 knots ;
2 turns ;

Here is the logical deduction which might have resulted from the bone-carving class in the Crannog at Lagore.

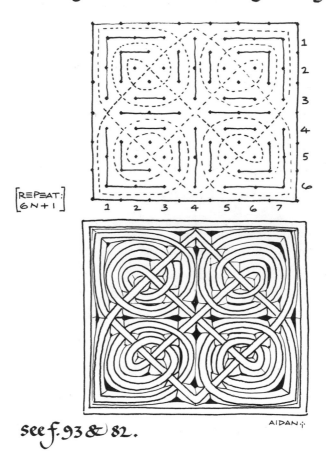

[REPEAT:
6 N + 1]

see f. 93 & 82.

AIDAN.

fig.96 Ornamental Serif, Lindisfarne, folio.3 *

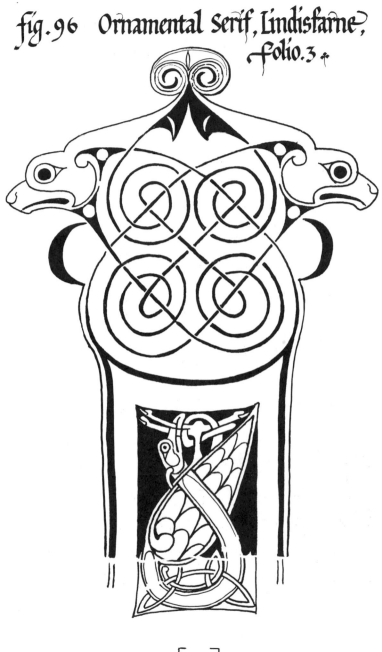

fig. 97 Spiral Knot; Lindisfarne; dot & grid construction:

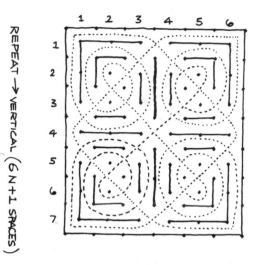

REPEAT → VERTICAL (6N+1 SPACES)

REPEAT HORIZONTAL (5N+1) →

This is the construction of the knot at *fig.* 96, which is black path line on open, white background. *Opposite*: more con‐ventional, white on black.

fig. 98 lindisfarne spiral knot panel,
path/ground reversal,
white on black:

a

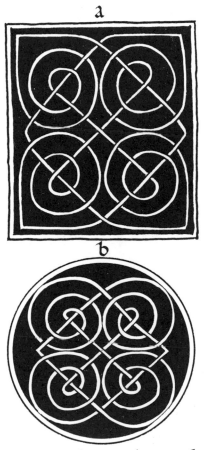

b

Any square panel may be made circular.

fig. 99 Spiral knot panel; 16 units; dot-&-break grid:

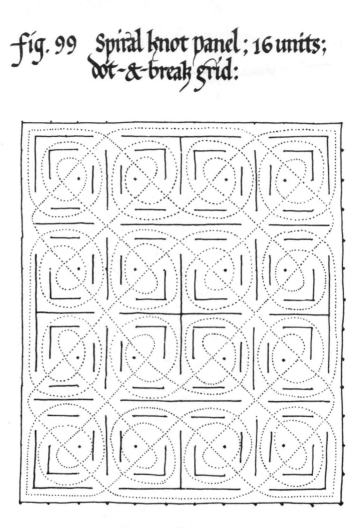

Let n equal number of repeat units:
Eleven spaces across; $2\frac{1}{2}n+1$, n=4.
Thirteen spaces down; $3n+1$, n=4.

fig.100 spiral knot panel; 16 knots:

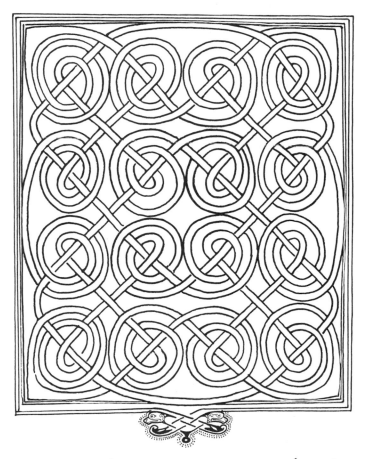

Background may be left open, or filled in.

fig. 101 Border Design, full page format;
 adapted from the book of durrow:

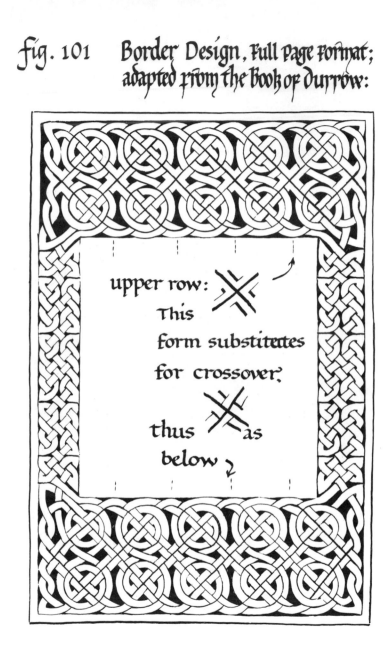

fig. 102 Durrow Border spiral knot;
single unit; dot grid, breakline &
keyline construction:

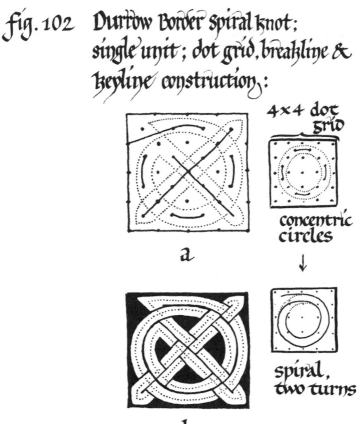

4×4 dot grid

concentric circles

↓

spiral, two turns

a

b

Where the ribbon is broad, parallel segments as here in the diagonals, or concentric segments as in the spiral, share a common edge, the keyline.

fig. 103 Spiral Knots ; 2 units ; Construction:

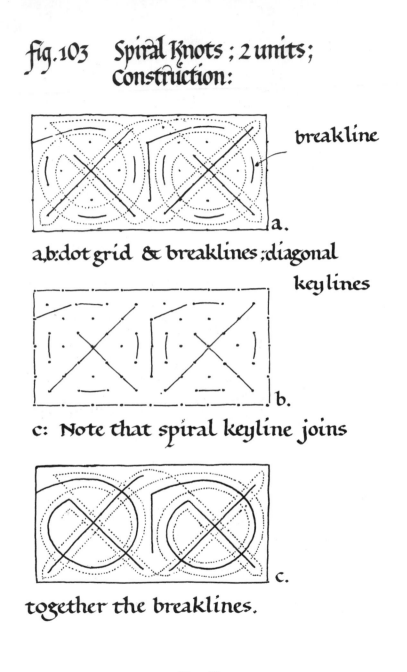

breakline

a.

a,b:dot grid & breaklines ;diagonal keylines

b.

c: Note that spiral keyline joins

c.

together the breaklines.

fig. 104 Spiral Knots; 4 units; Construction:

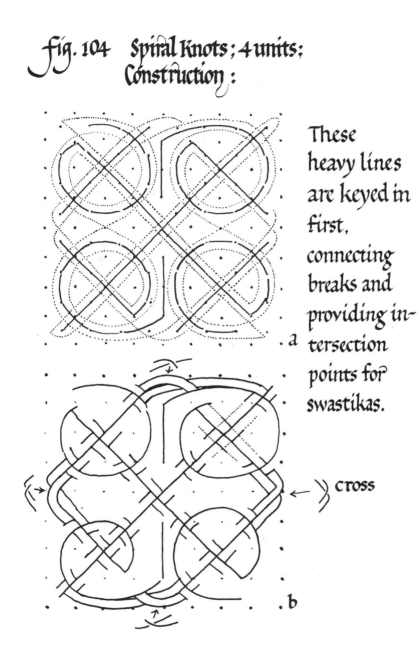

These heavy lines are keyed in first, connecting breaks and providing intersection points for swastikas.

a

cross

b

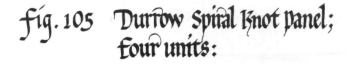

fig. 105 Durrow spiral knot panel; four units:

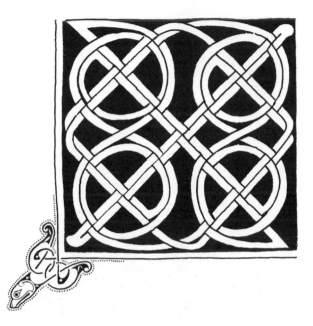

Look closely at this knot & compare it with the keyline-and-swastika method of previous page. The construction lines are still evident in the final stage, as here.

fig. 106 Durrow spiral knot panel; six units:

keyline a swastika

b

fig. 107 Durrow Spiral knot panel,
with integrated frame

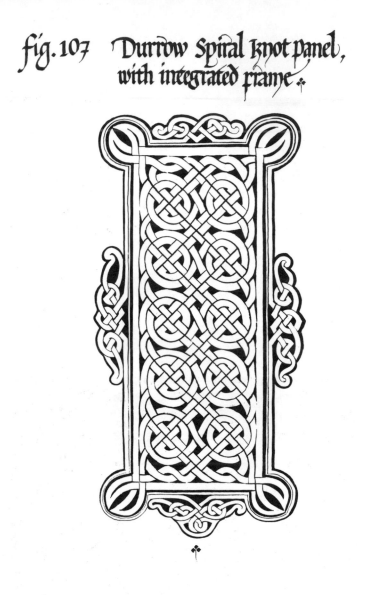

chapter xi
Spiral
knot borders

fig. 108

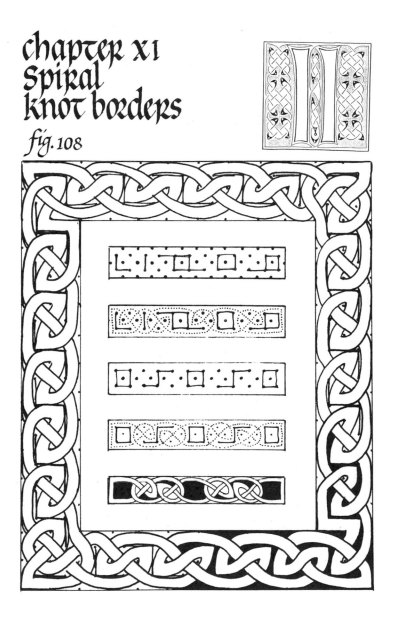

Figure 109: Romilly Allen's twelve Elementary Knots

(Taken from "Proceedings of Society of Antiquarians of Scotland" Romilly Allen, Celtic art lover & historian

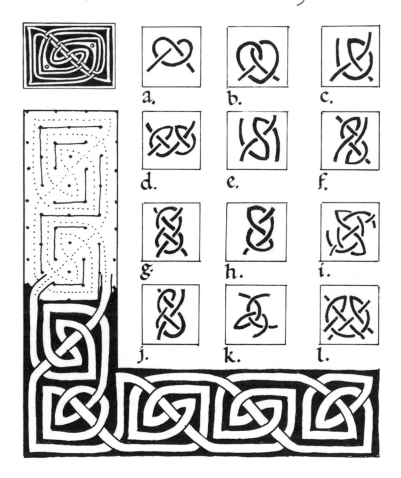

a. b. c.

d. e. f.

g. h. i.

j. k. l.

Figure 110: Analysis of Allen's knots.

Feb. 12, May 11, '83.

First published these in 1883.

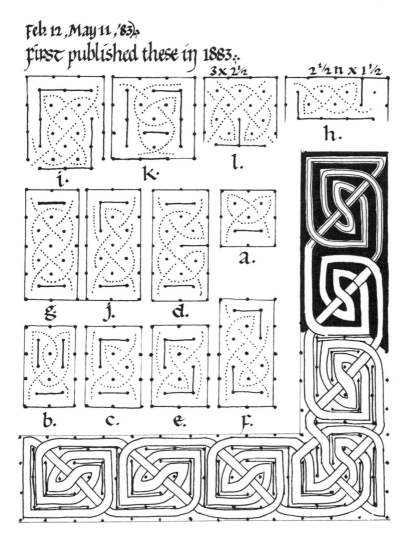

141

Figure 111: Spiral Border, Six Braid Knot.

The spiral border below right has a different construction for the mitred corner than here, left. The change is æsthetically better.

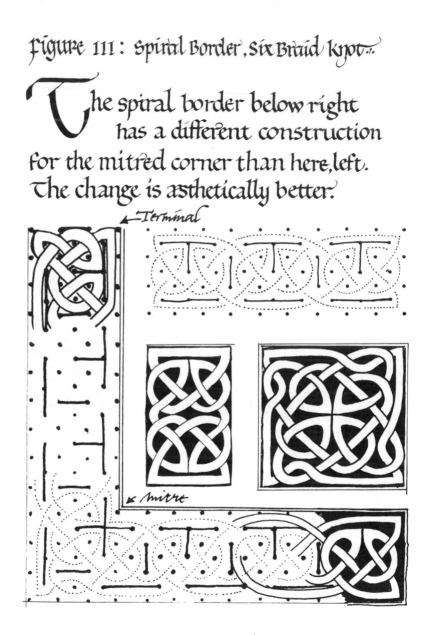

Terminal

mitre

The corner variants inspired
these square knots; also,
check out this split ribbon.

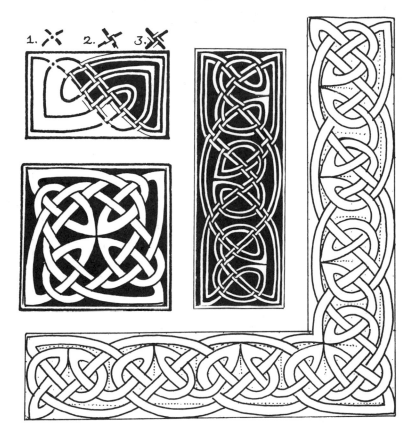

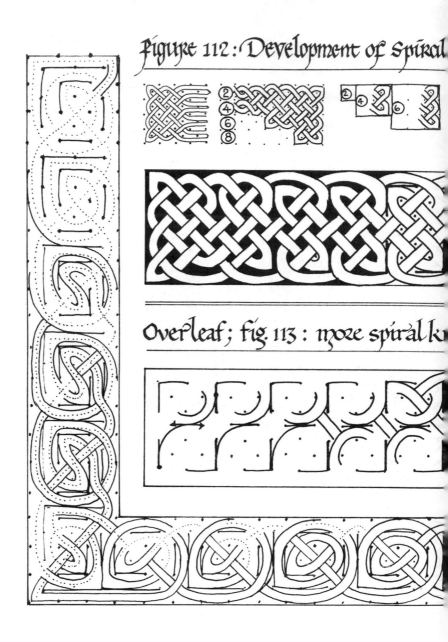

Figure 112 : Development of Spiral

Overleaf; fig. 113 : more spiral kn

[144]

not Border from Eight-cord Braid.

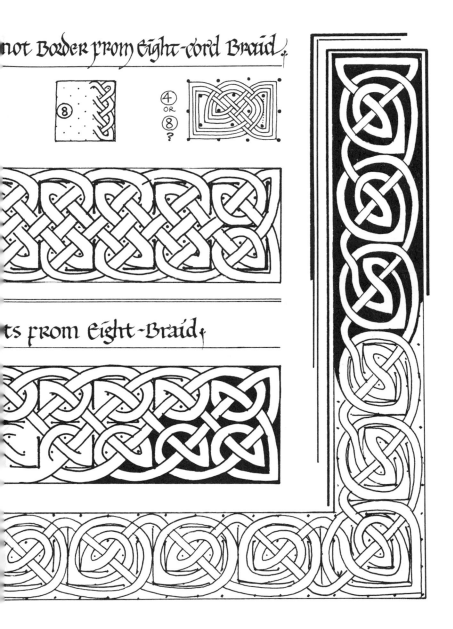

ts from Eight-Braid.

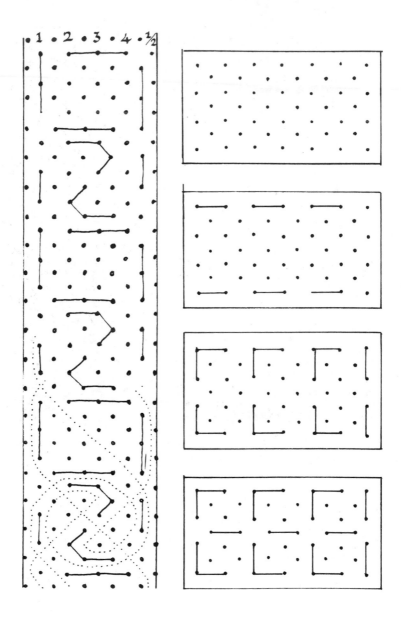

Fig. 113: Border from South Cross, Clonmacnoise, Ire.

Fig.114 four, five, eight & ten cord knots. Eight cord border from Book of Durrow.

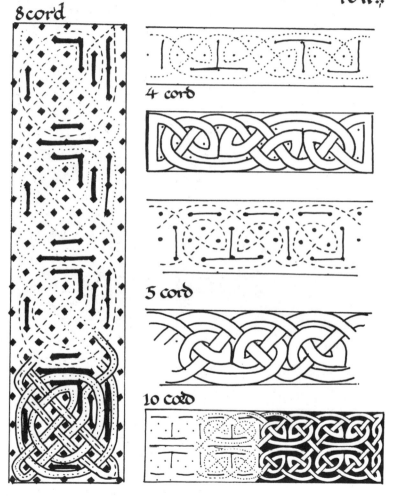

8 cord

4 cord

5 cord

10 cord

Appendix : Triangular Knots

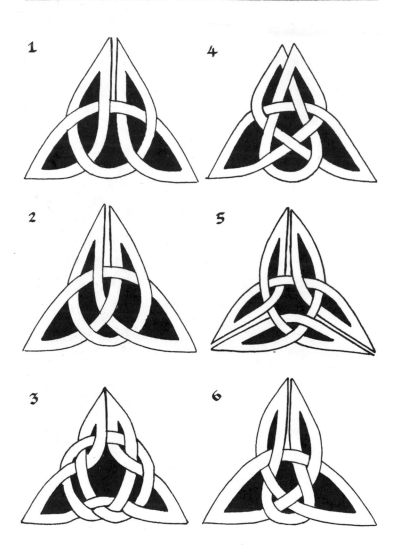

1

2

3

4

5

6

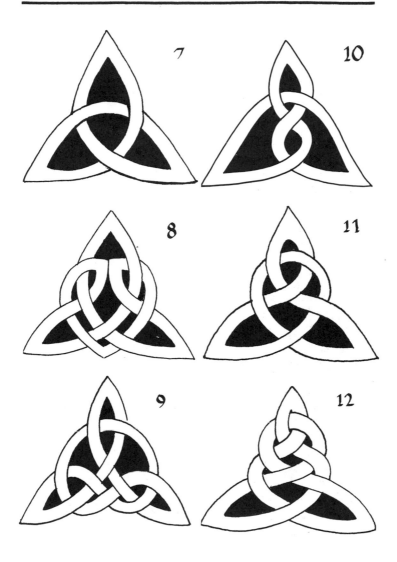

7

10

8

11

9

12

Appendix

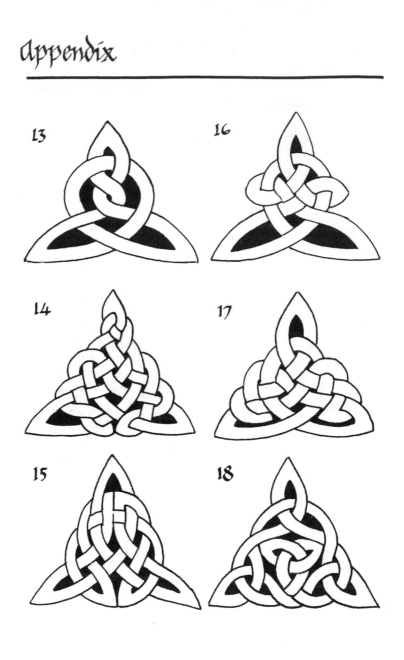

13

16

14

17

15

18

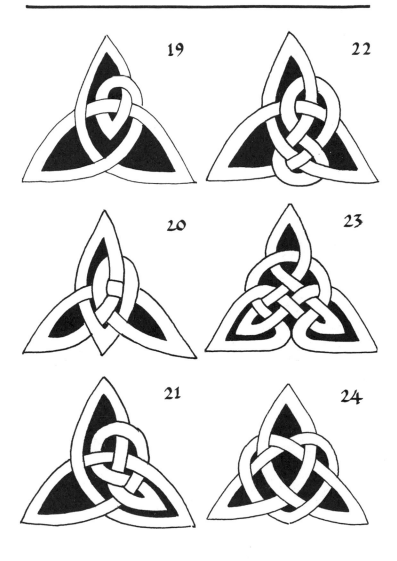

19

22

20

23

21

24

Appendix

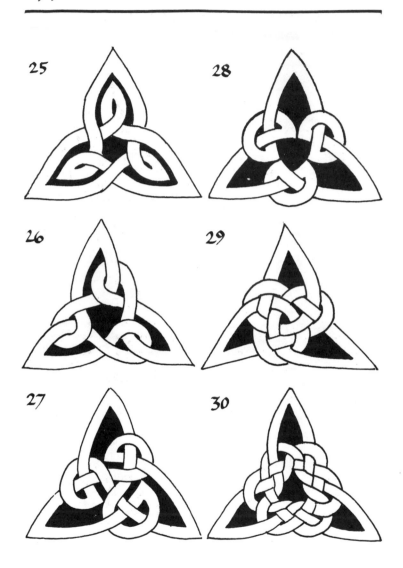

25 28

26 29

27 30

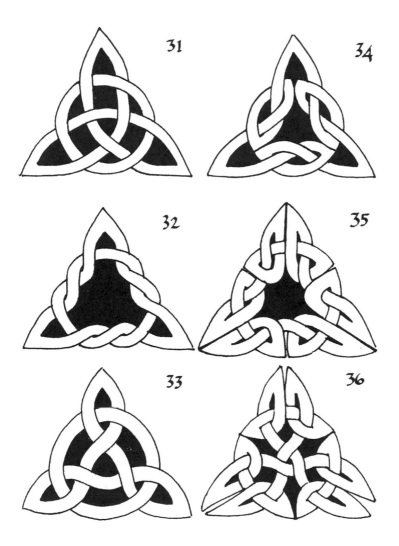

31

34

32

35

33

36

37

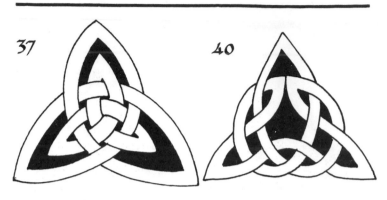

40

38

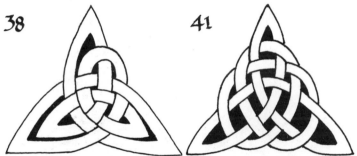

41

39

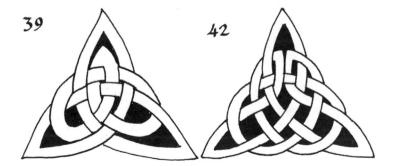

42

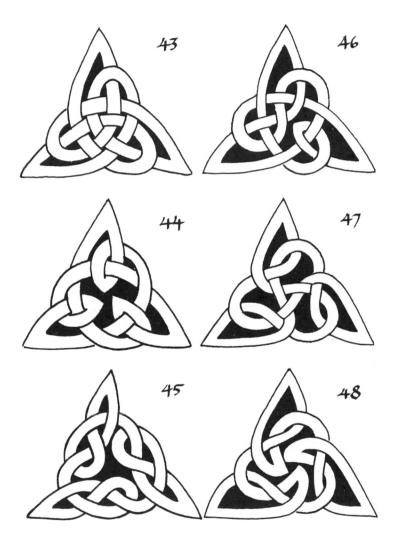

43

46

44

47

45

48

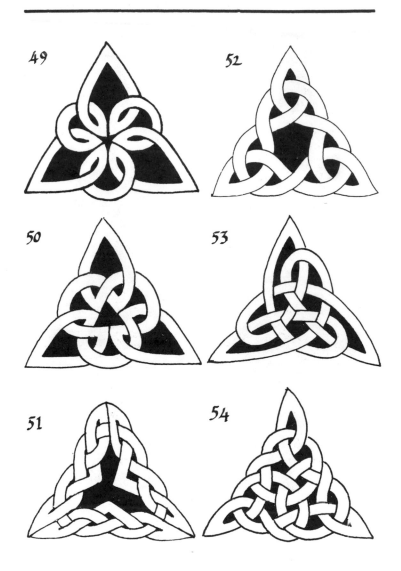

49

52

50

53

51

54

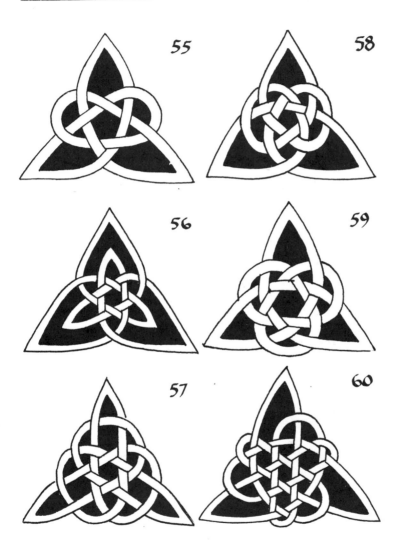